4/99

D0088305

Barbara Hepworth

St. Louis Community College
at Meramec
Library

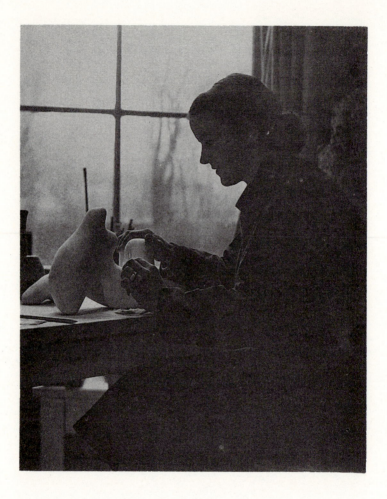

Margaret Gardiner

Barbara Hepworth

a memoir

with a Foreword by Sir Alan Bowness

WITHDRAWN

Lund Humphries Publishers
London

This edition of *Barbara Hepworth: A Memoir*
published 1994 by Lund Humphries Publishers
Park House
1 Russell Gardens
London NW11 9NN

Copyright © Margaret Gardiner 1982
Barbara Hepworth's letters © Sir Alan Bowness 1982
Foreword © Sir Alan Bowness 1994

All rights reserved. No part of this publication may be
reproduced, stored in a retrieval system or transmitted in
any form or by any means, electrical, mechanical or
otherwise, without first seeking the written permission of
the copyright owners and of the publisher.

British Library Cataloguing-in-Publication Data
A catalogue record for this book is available from the
British Library

ISBN 0 85331 674 0

Publishing History
Barbara Hepworth: A Memoir by Margaret Gardiner was first
published in 1982 by The Salamander Press.

Frontispiece and cover
Barbara Hepworth, *c.* 1935

Typeset by Nene Phototypesetters Limited, Northampton
Printed in Great Britain by
Hollen Street Press, Berwick-upon-Tweed

Foreword

Margaret Gardiner's memoir of Barbara Hepworth in Hampstead has acquired celebrity since it first appeared from a small Edinburgh publisher in 1982. It was republished in her collected writings, *A Scatter of Memories* (1988), and now makes its third appearance, once again in a single small illustrated volume.

Its unique quality arises from the fact that nobody knew the artist better, and received more confidences from her, often in the letters that she quotes here. Furthermore nobody has Margaret Gardiner's gift for writing about a society now disappeared – Hampstead in the 1930s – with such immediacy and vividness.

It was Barbara Hepworth who brought Margaret to Hampstead, as she did so many of those who were to make up her circle of artist friends – Henry and Irina Moore, Ben Nicholson, Herbert Read, Adrian Stokes, to be joined later by Gabo and Mondrian.

Margaret's pretty Regency house became the centre of many radical causes, in both art and politics. She was one of the very few who championed the revolutionary modern art of Hepworth and Nicholson in the 1930s, long before any recognition came their way. Every pioneering artist desperately needs support and understanding, and this is what Margaret Gardiner was able to give. Her acquisitions of painting and sculpture were always made in a supportive and not an acquisitive spirit, and it is entirely in character that she should in due course have given her collection away – to establish the Pier Gallery in Orkney, which will benefit from the royalties of this book.

Margaret's friends encouraged her to write about Barbara – our

regret is always that she did not write more. Not as an art critic, for she has never wanted to write about painting and sculpture, but as someone who could express the feelings and ideas that animated her generation. When you turn the page, and enter the world that she conjures up in her sparkling words, the proof of this will become immediately evident.

Alan Bowness

Acknowledgements

The publishers wish to thank the following: Sir Alan Bowness for permission to reproduce Barbara Hepworth's sculpture and to publish extracts from her letters; Sarah Bowness (for providing the photographs on pages 39 and 40); the late Ben Nicholson (for providing the photograph of himself, the author and Herbert Read, page 59); and Lady Read (for providing the photograph of herself and Herbert Read, page 32). The photograph of J. D. Bernal (page 53) is reproduced by kind permission of Peter Lofts Photography, Cambridge. The photograph of Herbert Read (page 30) is reproduced from *A Tribute to Herbert Read*, Bradford Art Gallery and Museums, 1975. The photograph of 'Two Forms' (page 29) is reproduced from *Barbara Hepworth* by J. P. Hodin, Lund Humphries, 1961. The photograph of Barbara's studio is reproduced from *Unit 1*, ed. Herbert Read, Cassell, 1934. The photograph of Ben Nicholson is by Humphrey Spender and is reproduced by kind permission of the National Portrait Gallery, London. The photographs of Barbara Hepworth (cover and frontispiece, photographer unknown), Solly Zuckerman (page 11), Paul Skeaping (page 16), Adrian Stokes (page 22), Barbara with Simon (page 37), Gabo in Cornwall (page 43), and Margaret Gardiner in the Alps (page 15), and the FIL pamphlet (page 49) are in the possession of the author.

Illustrations

One day in early 1930 Solly Zuckerman said to me, 'I'd like to bring a friend of mine to meet you. Barbara Hepworth – a sculptor and a very good one too.'

It was the first time that I had heard of Barbara. 'Yes, do bring her,' I said.

Solly brought Barbara to tea a few days later and the unexpected strength of her grip when we shook hands startled me. It seemed at variance with the general impression of delicacy that she gave; in fact, though slim, she was sturdily built. She was beautiful – brown haired with a high, sloping forehead, finely drawn eyebrows, dark-lashed brown eyes, a straight, determined nose and a firm mouth. Her skin was pale and very clear and everything about her seemed outlined, defined. She was neatly dressed and she carried a neat umbrella – she was altogether different from the picture of artists that I had gained from meetings in Vienna and Paris. There seemed to be nothing of their free and easy ways about Barbara as she sat there, upright, smiling and silent, looking about her while Solly and I talked and we drank the first of many hundreds of cups of tea that Barbara and I later drank together.

Before they left Barbara said, 'You must come and see me in my studio soon'. And next day Solly rang me up. 'She likes you', he said, almost as though that surprised him.

Barbara's studio was one of a row of single storey red brick studios – the Mall Studios – in a cul-de-sac off a cul-de-sac in Hampstead. It was surrounded by trees; a mud path led past the doors to where

No. 8, at right angles to the rest, brought it to an end. Barbara lived at No. 7. Inside, her studio was white and light and peopled by carvings on stands and tables in various stages of creation; in the far corner was a big cageful of birds. At first I scarcely noticed the carvings; I was fascinated by Barbara herself and for a long time didn't do more than glance at them. I only gradually began to look at them, as it were through the back of my head – and then later through eyes newly awakened by Barbara.

Barbara totally redefined the meaning of the word 'work' for me. Work was at the centre of everything for her; it was what sustained her through all the stresses and strains of her life. 'I've got into such a good rhythm of work I feel I would rather die than be stopped' she wrote to me once. It was a recurrent theme – 'I'm not fit to live with unless I can do some work – even an hour a day keeps me civilised'. And again – 'Although one so easily gets apparently exhausted, the work itself is nourishing in a durable way, unlike every other sort of activity'. By 'work' she meant, of course, carving, not chores – although she didn't despise these. 'The experience of household chores & menial work brings one quite a bit nearer a true insight.'

Some of Barbara's acquaintances found it hard to understand her attitude to work – they thought her stand-offish and were offended · if, when they dropped in casually, she would say 'Sorry, I'm working' and would firmly shut the door. Her friends knew better.

After that first visit to the studio others quickly followed, for Barbara and I were immediately at ease with one another and able to talk about everything and anything – and particularly about our own problems. 'You know me better than anybody else and will understand how I feel,' she wrote to me many years later. 'When I express a thought to you, you know what I mean.'

So we talked and talked, smoking and drinking tea until, as often happened towards midnight, Barbara would exclaim, 'I'm ravenous! I'm dying of hunger! Aren't you?' Then she would go to the kitchen and grill steaks which we would eat with all the gusto of schoolgirls at an illicit midnight feast. We both of us loved food.

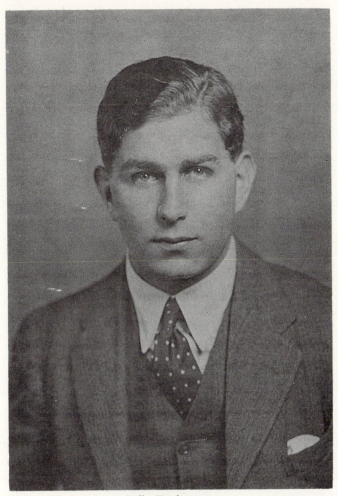

Solly Zuckerman
c. 1936

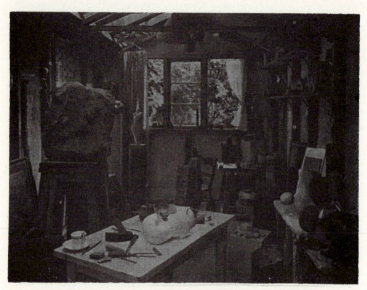

Barbara's studio in Hampstead (Plate II in *Unit 1*)

I, who had come from a very different background, was amazed at the way Barbara seemed to take everything in her stride – cooking as well as all the other domestic chores, caring for her little son Paul, and 'work'. Everything that Barbara did was done in a professional way, there was nothing slapdash or dilettante about her approach to any task. Once, I remember, I asked her whether she could play chess and she told me – to my surprise – that when she was younger she had played obsessively, had learnt all the openings and studied championship games. But when she came to realise that chess was absorbing the greater part of her time and energy, she decided to stop playing, and stopped completely.

In the early days of our friendship and before the war had forced everyone to become – however ineptly – more or less self-sufficient, I once rang her up and asked, in all innocence, 'Barbara, how does one roast a chicken?'

Barbara laughed and laughed. 'Oh, Margaret!' she said – and told me how to do it.

In spite of the drudgery that invaded her life and from which she couldn't escape, in spite of her own frequent ill health and the illnesses of her children, Barbara always snatched every opportunity to work. 'I work to a very simple & single minded philosophy & always tell myself that I must & will do everything,' she wrote in a letter to me. '. . . For me there is a special creative pleasure in letting or forcing my mind to surmount tiredness – of course this makes one *more* tired but on the other hand the victory is so exciting it makes it possible to surmount even that!'

All the same, during the war, when so much was demanded of everybody, she slightly relaxed this severe discipline that she had imposed upon herself. 'You'd be horrified if you could see how much I've neglected everything lately in order to work. I'm only vaguely worried now by spiders' webs & dirty windows. It's against all my early training & really against all my real feelings but "time" gets more elusive every day & I can only pin it down by a concrete thing like a drawing or carving.' And again, 'One can easily expire

bothering about moths & cleanliness & cabbages & so on & for what purpose?'

I think that Barbara's passion for work, her utter dedication to it against all odds, was in part sustained by the excitement of being a pioneer. For she and a number of her fellow artists were exploring completely new possibilities in art and making totally new discoveries – '. . . Today seems alive with a sense of imminent new discovery,' she wrote in *Axis*. These artists did not constitute a school, or a group with a manifesto and defined ideas about what should be the nature of contemporary art – rather, each was finding his or her own way among the new ideas. But what, I think, drew them so much together was a shared and passionate belief in the power of art, and the conviction that society could be changed through art. They were nearly all of them deeply concerned with the social problems of the day and particularly with the rise and growth of fascism and the threat of war.

It was not an easy path that they had to follow; at that time their work got little recognition and sales were few. For some it was a long struggle against poverty – even as late as 1944 Barbara wrote to me from Cornwall, 'He [Jim Ede, who had been visiting them] bought three *little* paintings of Ben's & though he may not realise it, completely saved our life – we were at bottom & could not pay school bills or grocer!'

Barbara, when I met her, had recently been separated from her first husband, Jack Skeaping, and although she was sure that she had made the right decision – and Barbara never made important decisions without thinking them through – she still felt vulnerable and was disturbed about the effect the breach seemed to be having on her son Paul. Before Jack left, she told me, Paul had been beginning to speak, but now he had reverted to gesture and babble and this Barbara attributed to the fact that he was missing Jack.

Paul was a beautiful and lively little boy; at first I rarely saw him, for I always visited Barbara in the evenings when he was already in bed and asleep. But when he was four years old I briefly ran a small

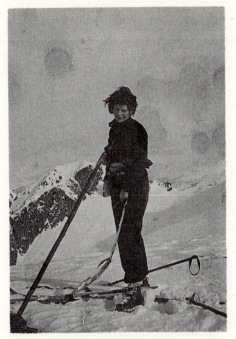

M. G. in the Alps 1935

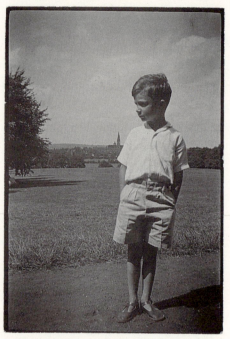

Paul Skeaping on Hampstead Heath

nursery class to which he came and so I got to know him well. At that time Barbara was again worried about him because he was refusing to eat – and this she attributed once more to his bewilderment and resentment over Jack's absence. She would sit with him for hours on end trying to coax him to eat and found it hard to believe that at lunch in the nursery class he ate as heartily as the other children. She found it hard to believe, too, that he could be rowdy and obstreperous, for at home with her in the studio he was always quiet and compliant. He adored Barbara, and his face would light up and there was a note of reverence in his voice whenever he spoke her name – 'Barbara'.

Another cause of worry about Paul was that the charwoman quite often took him out for walks and he began to develop a cockney accent. This bothered Barbara a lot and she tirelessly corrected it. Her sister Elizabeth told me once that when she was looking after Paul she asked him, as he strutted round the room, tootling on a rolled up newspaper, 'Who are you, Paul? Are you the Pied Piper?'

Paul looked at her reproachfully. 'You mustn't say piper,' he said, 'you have to say *paper!*'

When Paul was nine years old, Barbara decided that he would feel more secure if he had no doubts about which was his *real* home – with her or with Jack. So she asked Paul himself to choose and he chose to live with Jack. At the time I was puzzled; I thought it too much to ask of a child to make such a choice. But perhaps Barbara realised that life in the studio with her was too constricting for him and with Jack he would have an outdoor existence with horses and dogs and masculine pursuits.

Of course Paul often spent the holidays with Barbara, but later on he reacted strongly against her environment. When he was seventeen she wrote to me from Cornwall, 'Paul seems much more poised than before – v.v. charming. We have a close physical contact but not much mental contact as he almost hates sculpture, ptg, music & books!'

Paul became a pilot in the R.A.F. and was killed in an air crash over Thailand in 1953 . His death was a lasting grief to Barbara.

She wrote to me soon afterwards, 'The vitality & radiance in Paul, the light he always brought into a room . . . seemed impossible to associate with an early death. And yet, always, at all times when I regarded his special quality which so warmed me – some sadness and shrinking seemed to twist my heart.'

In 1931 Barbara met Ben Nicholson. She had been on holiday in Suffolk with a group of friends and among them were Henry Moore and Ben. She came back full of happiness and hope. She told me about Ben – what a beautiful person he was, how magical his paintings – and soon she had arranged for me to meet him.

I think that one of the first things that I noticed about Ben was the way he moved; he moved with such style and precision and yet with ease. Indeed, everything about him was stylish and elegant – the way he stood, the way he wore his clothes, the tilt of his cap on his already bald head, even his teasing smile. He was jaunty, he made atrocious puns with an air of finality and 'I should have thought' he would begin mildly, easing his way into some dogmatic statement. His complete self-confidence had nothing of arrogance but was probably fed by his immense charm. All the same, at first I didn't like him much. I thought that he treated Barbara – that Barbara whom I so admired and respected – in far too breezy a way. I remember once in the street, when we were all three waiting for a bus, Ben suddenly lurched up against her with his shoulder, like a footballer, saying 'Oh, sorry' in mock contrition. I felt absurdly indignant – but Barbara only smiled.

It wasn't very long, however, before I came round to Ben, capitulating to his charm and entranced by the magic of his paintings. Much of both the man and his work shines through his own description (in *Unit 1*) of his way of painting: 'One can express a thought by taking a piece of stone & shaping it, or 2 pieces of stone & shaping them for 200 years, one in relation to the other & both in relation to time in space. Or one can take a piece of cardboard

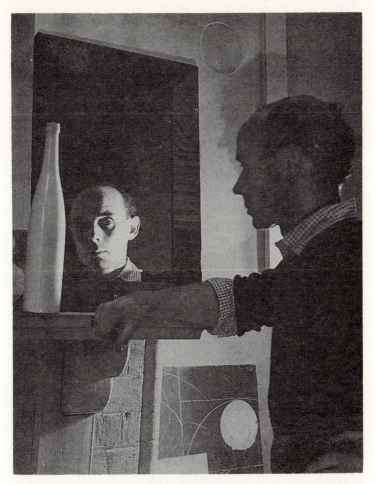

Ben Nicholson
c. 1933
(*photograph by Humphrey Spender*)

& cut out a circle one depth, or 2 circles 2 depths, or 600 circles 6,000 depths, or one can take a board & paint it white & then on top put a tar black & then on that a grey & then a small circle of scarlet – then scrape off some grey leaving black, some black leaving white, some white leaving board, some board leaving whatever is behind & some of that leaving whatever is behind that – only stop when it is all the form & depth & colour that pleases you most, exactly more than anything has ever pleased you before, something that pleases you even more than pleases yourself then you will have a living thing as nice as a poodle with 2 shining black eyes.'

In the summer of 1932 I was unhappy about a broken love affair and Barbara urged me to go and stay at the farmhouse on the Suffolk coast where she herself had been so happy. In that tranquil country-side, she assured me, I'd be able to come to terms with my prob-lem. That would indeed have been Barbara's way; as she wrote to me once, 'I've been a good deal perturbed lately about many problems which have arisen. The problems have been so many & so varied that I've had to investigate each & every idea I've ever had – a complete mental "springclean".' But loneliness and landscape were not what I needed then and I came back more depressed than ever. 'People work things out so differently,' Barbara conceded – and took me in hand again.

Although Barbara believed, theoretically, in complete freedom and an uncritical acceptance of those one loved, she was in practice often dictatorial and very sure of the rightness of her own judg-ments. Now she insisted that I must leave my mews flat, get away from the car fumes and river mists of Knightsbridge and move uphill to Hampstead. I must, she said, take the top flat in Jim Ede's beautiful Georgian house in Elm Row; the change would do me the world of good and besides, it was not far from her studio and we would be able to see more of each other. In my state of despondent apathy I was only too glad to have a decision made for me and so, as soon as I was able to let my flat, I moved into the light and airy rooms in

Hampstead. Barbara had been right; almost immediately I felt more cheerful.

Barbara's advice was nearly always both helpful and robust – a favourite word of hers. At another time and about another problem, during the war when we could only rarely meet, she wrote to me, 'Have you tried writing down *exactly* what comes into your mind – without any sort of control no matter what horror comes out? It does help in extremity because the conscious act of forming things creatively is a terrific strain through the eternal "selection". A lot of stuff gets rammed down out of sight. I'm glad I'm a sculptor because in anger or despair I work off steam roughing out & swear horribly sometimes. Painters take a rag & turpentine & swipe out all they've done – that is a fearful shock. I don't think any artist is sane by accepted standards – but as universal "sanity" seems to consist of finding rational reasons for irrational behaviour it seems a pity that education through art cannot be developed quick enough to preserve that human madness so indispensable to survival.

'Look at the new desire on the part of society to get artists to conform to church – State – Baptism & God knows what. The old idea of drink & licence in the mind of the masses was much healthier. Don't you agree?'

Barbara took up this theme in another letter: 'I always think it's a subconscious thing that comes about by terrific hard work . . . when one feels desperately ready to destroy the whole thing & then ready to lose it all something gets past the barriers. It always seems to me that only by long concentration can one get past what one knows to what one doesn't know that one knows.' And again, about psycho-analysis: 'What are the deep impulses to create? Some sort of clash & sparks buried deep down, conflicts & torments & extremes. I feel it is dangerous to remove them though without a doubt placidity would emerge.'

I took Adrian Stokes to the studio to meet Barbara and Ben. Adrian was, I think, the most marvellous looking man that I have ever met.

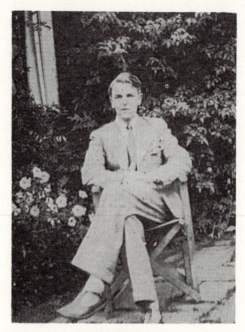

Adrian Stokes

He was like some magnificent bird – tall, with a crest of unkempt fair hair, blue eyes, sweeping eyebrows like wings and a beak of a nose. His eyes were usually lowered but when he looked up and opened them, the effect was electric. His hands, too, were exceptionally beautiful, large and supple. He always spoke very quietly and sometimes devastating things were said in that gentle voice. Once, I remember, I took him to dine with a young Fellow of a Cambridge college and the talk was both boisterous and high-brow.

'Why are dons always so shrill?' enquired Adrian mildly. I was taken aback at the astonished silence.

Adrian was a great dab at nicknames and used them with casual assurance, slyly certain that his listener would be bound to recognise to whom they referred. Then – and after saying anything that he knew to be outrageous – he would give a quick flip of the tongue to the side of his upper lip.

The meeting between Barbara, Ben and Adrian was a success from the start. They liked each other and they were deeply interested in each other's work and ideas. 'Stone (is) . . . the basic inspirer of visual art,' Adrian had written. He was particularly fascinated by Barbara's carvings about which he wrote in a review in the *Spectator* in 1933, 'A glance at the carvings shows that their unstressed rounded shapes magnify the equality of radiance so typical of stone; once again we are ready to believe that from stone's suffused or equal or slightly luminous light, all successful sculpture in whatever material has borrowed a vital steadiness, a solid and vital repose. . . . Miss Hepworth is one of the rare living sculptors who deliberately renew stone's essential shapes.'

In a separate review of Ben's work in that same joint show at the Lefevre Gallery, Adrian wrote, 'You may approach the picture by observing how zealous is the lay-out of the exhibition's invitation cards or of its catalogue, how debonair the designs of the rugs and fabrics. Mr Nicholson can express the liveliest perceptions in terms of correspondence between two circles, so intense is his power to elucidate the plane on which they lie.'

The 'rugs and fabrics' were an attempt on the part of Barbara

and Ben to shore off poverty by producing objects cheaper and more saleable than paintings and carvings. The material difficulties of their existence were a constant problem and Barbara, less optimistic than Ben, worried endlessly. Once, in desperation, she told me, she had even made masks for Elizabeth Arden's salon – but she hated doing it. It felt like a betrayal of her sculpture.

It was characteristic of Adrian's insight that he should have picked upon the lay-out of the invitation cards and catalogue as a way of approaching Ben's paintings. They had, of course, been designed by Ben himself and I think that 'debonair' was exactly the right word for them. There was, indeed, something debonair – jaunty – about his arrangements in the studio of his special objects – the mugs and jugs, the white-painted moselle bottle, the brightly coloured fishing floats, the white pencils with their spirals of colour, blossoming out of a little crystal vase.

I find it puzzling that, observing and admiring such things, Adrian, whose life and work were concentrated on the visual, should himself have tolerated living in a mess. His flat in the Adelphi was a twilit silt of books and dust. He told me that once, having been in great need of a certain and rare book for his work, he was frustrated for months by being told, whenever he asked for it at the London Library, that it was out. At last he begged the librarian to tell him the name of the borrower so that he could plead with him to return the book. The librarian looked the matter up. 'A Mr Adrian Stokes has had that book out for the last two years,' he said. Adrian went home and excavated the book.

Both Ben and Adrian loved games and both were exceptionally good at them. They took to playing tennis together at the little club in Belsize Park – a splendid pair to watch. Ben, small, agile and quick, Adrian tall and lithe, his hair tied back in a snood to keep it from falling over his eyes, very hard hitting and very anxious to win. Barbara didn't care for playing games although she loved dancing and was an excellent dancer. Now she took it into her head – mistakenly, as I thought – to brush up her tennis in order to be able to play with Ben. So she asked me to play with her but it wasn't at

all a success because she, with her customary thoroughness and professional approach, just wanted to practise strokes, whereas I wanted knockabout games. My lack of seriousness annoyed Barbara and we very soon called the whole thing off.

Barbara was not always so serious. 'How I wish I could see you and have a bit of frivolity,' she wrote to me from Cornwall. I'm not sure whether love of clothes and jewellery is frivolous – but certainly Barbara and I frequently talked about them and consulted each other about our choices. I remember a time when Barbara turned up with fashionably cut and waved hair.

'What do you think?' she asked uncertainly.

'Well', I temporised, 'I'm not used to it yet'.

But there was no need to get used to it. However, when I appeared in the studio with bright red nails, Barbara didn't treat me with such tact.

'Margaret – your nails!' she exclaimed aghast. I wanted to sit on my hands for the rest of the evening.

During the war, when clothes were strictly rationed and materials were of poor quality, I wrote to Barbara about my longing for new clothes and bemoaning middle-aged drabness. This is what she wrote in reply: 'About clothes & our personal appearance. I've been thinking a lot about it lately – & I think it's a very real problem for people like you & me. I never thought it was going to be – in fact I used to look with scorn on people who fussed about growing old and bothered about this & that. But I can see now that we have got to think it out. I suppose that 90% of women quite simply grow into older women & grow into older women's clothes & hats & "hair do's". Especially when they have children & lose their figures & look forward to grandchildren.

'But chaps like us are a different sort of shape! Physically & mentally we have always worn odd sort of clothes & done odd sort of things – we don't feel in the least settled down or contented or stable. And I, for one, am not at all interested in grandchildren!

'I feel most definitely that when I have got the children safely though to adolescence that a new period will start for me, a period

of freedom & activity when there will be such a *lot* to be done. . . . But feeling this way I have some resentment about growing older & jaded – also I'm not quite sure how to do it gracefully! The average old women's clothes are appalling – at the same time there is nothing more painful than dressing in clothes too young & too obvious in colour & form. And yet I adore bright colours & definite shapes – so do you. Practically speaking then, what does one do – how to dress one's hair, what make-up to use, how to go grey elegantly – choice of clothes, shoes, jewellery are so much greater problems for us. I look at Mrs Backhouse (you remember her?) with her good tweeds, pearls, careful waves & shingle, & fur round her neck. She looks elegant & right. But I should look like an idiot in such clothes. . . .

'We have to evolve some personal style that is an *inspiration* to ourselves. Inspiration is a necessity otherwise one is overcome by tiredness. I feel at the moment just like you *say* you feel – a char, rough, tired, sallow & I hate it. The only thing to do is to think out a policy, stick to it & then devote oneself to work quite ruthlessly – then I expect a new kind of vitality will come quite independently of age & good looks.

'This all sounds silly but evolving the personality in clothing is really v. important. . . . I'm really keenly interested in the outward expression of social events as seen in clothing – it has always been most expressive & violently so before this war started. So it's natural to think about it & as you say to want new clothes.'

I introduced my Dutch friends, the archaeologist Hans (Henri) Frankfort and his wife, Yettie, to Barbara and Ben. Hans was a bubling, exuberant person with a constant rush of excited ideas. He had been on digs in many parts of the world – most recently in Ur of the Chaldees with Leonard Woolley – and he felt himself particularly well equipped to assess Barbara's work in a historical context. He wrote about it in *Axis*: 'Even as in music, not only the sounds but also the silences enter into the rhythm of the composition, so matter and empty space form in their harmony these carvings.

'By activating to the last degree the forces which lie dormant in her material Barbara Hepworth places herself not less in line with ancient sculptural traditions than by the sustained tensions of her compositions and a thoroughness of carving which leaves every particle of surface shaped and luminous. . . .

'As for her spatial disposition – the Apollo of Olympia (and no one should speak here who has not experienced the impact of the original upon his startled vision) includes as indispensable parts the empty space between chin and shoulder, arm and flank. The essentials of art are immutable.'

It is, I think, a significant measure of Barbara's intuitive discoveries that both an eminent archaeologist and an eminent scientist – J. D. Bernal – should have found in her work a relevance to their own disciplines. I had taken Desmond Bernal to the studio to meet Barbara and he was immediately fascinated by her carvings, whilst she was fascinated by his explanations of their scientific and historical parallels. He was later to write in the foreword to the catalogue of her 1937 exhibition at the Lefevre Gallery, 'This appreciation of the sculptures exhibited by Miss Hepworth is not to be taken as an aesthetic criticism. It simply expresses the relation of an extremely refined and pure art form to the sciences with which it has special affinities. The first impressions of the present exhibition suggest very strongly the art of the Neolithic builders of stone monuments. . . . Neolithic art is highly sophisticated and expresses the realisation that important ideas can be conveyed by extremely limited symbolic forms; that it is unnecessary to fill in details as long as general intentions are realised. . . . By reducing the traditional forms of sculpture it is possible to see the geometry which underlies it and which is so obscure in more elaborate work. . . . The negative curvatures and the twists [of her earlier work] have all but disappeared and we are treated to a series of surfaces of slightly varying positive curvature which enable the effects of small changes to be seen in a way that is impossible when the eye is distracted by grosser irregularities. . . .

'Finally, six pieces bring out the relationship of similar figures,

beginning with simple spheres and turning into discs and slabs of increasing complexity. Here the greatest thought has been given to exact placing and orientation. There is not, as in representational art, any literary relation between the two pieces, or, as in architecture, any functional relation. The separate surfaces are made to belong to one another by virtue of their curvatures and their precise distances apart, much as two sheets of a geometrically defined single surface.'

There was a pendant to this in a letter to me from Barbara many years later: 'Yesterday we moved 2 big stones close up together, very very slowly. It thrilled me absolutely because as they drew together I saw all the shapes take on significance & what had been, up till now, a mental image took on reality.'

The relation between science and art was a constant preoccupation of Barbara's, as it was, indeed, of many of her artist friends and particularly of Naum Gabo. 'I can't see how science and the human spirit can be reconciled,' she wrote, 'unless there is a clear majority of men of the calibre of Desmond. Will Des ever have the time to think about his Science & Art book? I should dearly love to talk to him. I think there will be a new form of ethics – social & political – very *much* to the good & what we had hoped for – but the speed is out of proportion in the world of invention to the detriment of poetry & aesthetic vision. . . . I cannot see any hope of stopping this suicidal impulse unless Art & Science stand firm together.'

Towards the end of 1932 Ben and Barbara had a joint exhibition at the Tooth Galleries and Herbert Read wrote the foreword to the catalogue. Herbert, whom Barbara greatly loved and admired, lived a few doors away from her and Ben in the Mall and I often met him in their studio. He had a wonderfully serene presence; tall and with a beautiful, smiling and gentle face, he was extremely silent. But Herbert's silences were neither arrogant nor shy – they seemed, rather, to be manifestations of an inner certainty and knowledge. All the three of them from Yorkshire – Henry Moore, who also had

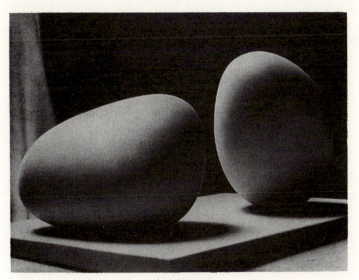

Two Forms

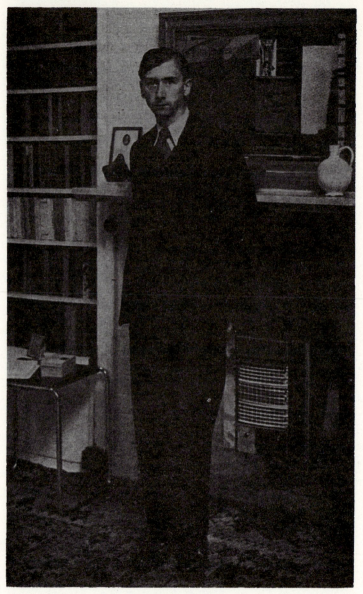

Herbert Read

a studio nearby, Barbara and Herbert – disliked small talk and only spoke when they really had something to say. The story went that during the course of a long afternoon with a young American admirer of his who had come to Europe specially to meet him, Herbert said 'Yes' twice and 'No' once.

Margaret Ludwig, whom we knew as Ludo and who later married Herbert, often came with him to visit Barbara and Ben. She was a talented young musician, small, dark haired, dark eyed and with a very deep voice. Speaking rather slowly, she would make capricious remarks with an air of intense solemnity while Herbert, head slightly to one side, watched her with delighted amusement. Once, I remember, she came teetering in on very high heels of which Barbara and I, both confirmed low-heelers, intolerantly disapproved.

'But I prefer to walk on my toes,' said Ludo. 'Like a cow,' she explained.

'Like a cow?' I asked, puzzled.

'Yes, cows walk on their toes – didn't you know?' she said. 'Those knobbly things half way up their legs are their heels.'

'Ludo is a hoot,' said Barbara, who would from time to time lapse into prep-school jargon: 'goody goody gumdrops,' she'd say, and 'oh, golly gosh!'

Barbara loved birds. During a very cold winter in the war she wrote to me, 'It has become an obsession with me to try & give food to the rarer birds – bullfinch, chaffinch, golden crested, the tits, the wagtails. I cannot devise any system that works. The starlings beat me every time. They are so socially organised that they can plan & meet every contingency. Yet the sight of one tiny & rarer bird fills one with joy of living & is surely very relevant to the whole – more so than the noisy fighting & squabbles of the starlings. It is amazing that the world isn't full of starlings!' Which was, I think, also a political comment for at about the same time she wrote: 'I've been feeling quite dismayed recently by some of the political remarks

Herbert and Ludo Read
Gruyère

made by people I know quite well & am friendly with,' and again, 'I feel v. lonely at times, particularly these days when there are such political rifts & such a sense of urgency'.

Once, when we were still both in Hampstead before the war, Barbara asked me to go with her to hear the dawn chorus on the Heath. We walked in the dark towards Kenwood, somehow compelled by the mystery of the night to talk in whispers. Suddenly the song of a single bird broke a silence soon splintered by twitterings that grew with a crash into the full clamour, the glorious muddle of sound. Gradually the chorus frayed and dwindled, absorbed as it seemed by the misty beginnings of morning, into every-day, intermittent bird-song.

We drove down to Covent Garden where, in the half light, the colours of fruit and flowers glowed magically. Men, unloading baskets and boxes from lorries, or pushing piled up trolleys, shouted at us encouragingly; the whole bustling market was alive with cheerful male warmth. Hungry now, we went to one of the all-night cafés and ate an enormous breakfast of bacon and eggs and drank cups of very strong tea. It was full day when at last we returned to Hampstead.

More than forty years later when I visited Barbara in Cornwall a few weeks before her death, she reminded me about that morning. 'Wasn't it lovely?' she said.

One evening I found Barbara extremely disturbed. She told me that she'd been to a party the night before at which one of the guests, an Indian woman, had been reading palms. But when Barbara held out her hand the woman looked at it and shook her head.

'No,' she said, 'I don't want to read yours.'

'Why not?' asked Barbara, frightened. 'Go ahead – please do'.

But the woman still refused. Barbara, who was not at all superstitious, who didn't believe in fortune telling, was very badly shaken. What horror had that woman imagined that she saw in her hand, what terrible fate?

'If she'd only told me,' said Barbara, 'then I could have laughed it off. But now – why did she refuse? Why was I the only one that she refused?'

Barbara was an intrepid person; certainly she was often anxious, she worried a great deal about money, about journeys, about missing trains and such matters. But when it came to the real problems of her life she faced them with great courage and I only remember one – endearing – episode when a very small thing indeed frightened her. Desmond and I had rented a cottage in Essex for half-a-crown a week. It was primitive, without electricity or water and with an outside earth closet. But the rooms were light and pleasant and dry, and there was an overgrown little orchard with apple trees – and I loved it. So I invited Barbara and Ben to stay one weekend, but from the moment they arrived I realised that it had been a mistake. They didn't like it at all.

'I can't do any work here,' said Barbara. 'I can't spend a whole weekend without working. Besides –' and she suddenly screamed and jumped nimbly onto a chair.

'A mouse!' she exclaimed in horror. That was the end of it; they got into their car and drove away.

It may have been because she was extremely logical that Barbara could at times be fierce, even ruthless, in a way that I found it hard to understand. This letter, written to me during the war, still puzzles me: 'When your letter came I sat down & asked myself what I really thought & the answer is – I hate. I hate wholeheartedly & passionately.

'The world was already becoming civilised in some ways & we have been within an inch of all reality, all knowledge, all love & creative energy being exterminated for perhaps ever. In its place there would be a ghastly paganism & withering of the spirit too ugly to contemplate. One does not need to be in a concentration camp to imagine the murder, rape, lust, torture & lying which the Nazi & Fascist doctrine would impose upon the world.

'By international law (roughly speaking) a man is hanged or electrocuted or imprisoned for life for *one murder*. What a fantastic thing it would be if we allowed mass murderers to live. Unless we hate with passion every Nazi German, every French Quisling, every Nazi Jap, every Fascist thinking man & woman & punish them accordingly after the war, we are guilty of treachery *now* in allowing our men, our airmen & men at sea to lose their lives in this war.

'Further – we must continue to hate for years after the war until every Nazi potentiality is torn right out of our own country & our own souls. The Nazi doctrine is evil – sheer concentrated evil. We cannot love good if we tolerate evil – we've tried that between two wars & look at Spain & the smirch on our own spirits.

'My own fear is that we shall consider ourselves too gentlemanly if we win the war to exercise the law on such a vast scale, but if we fail to do so our own children will die & their children would be better not born. . . .

'I honestly believe that unless we hate evil with passion, sustained, logical & ruthless – we shall ourselves sink into suicidal apathy.

'As far as Germany is concerned – we all thought that the atrocity stories of the last war were just stinking propaganda. But they must have been true for such a nation to succumb to mass atrocity 25 years later.

'Heavens – the crime against the Jews is sufficient just by itself for us to insist on a proper, full & detailed settlement by law.

'The good Germans, the good Italians & the good Japanese must, alas, bear a heavy load in carrying on & rebuilding the essence & purity intrinsic in their countries. It will be a heavy load but worthwhile to men of spirit. And we ourselves must prosecute with energy in England the tearing out & killing of the inherent evil in our own selves & people. The only way in which we can "keep pity alive in our hearts" – [I think that here she was quoting from my letter] – is by exercising just punishment (even if it means killing 10 million Axis men) on behalf of all those who have borne the suffering & on behalf of those still unborn.

'I love the great sympathy & understanding in you, dear Margaret, which makes it impossible for you to hate. It is part of your creative beauty but it cannot, in itself I feel, meet reality today. We are too far gone to be saved by gentleness.'

Perhaps Barbara was right, perhaps if we had torn every Nazi potentiality 'right out of our own country and our own souls' the later recrudescence of fascism could have been contained. Perhaps. Nevertheless it was not just vengeance that Barbara was demanding; she was too poignantly aware of suffering for that. She could also write: 'There is such vitality & beauty in poetry, music, forms & colour that the devastation & suffering everywhere is almost beyond comprehension. One has either to face the 2 things side by side & be torn asunder by the extremes – or turn away & just enjoy what comes along, which is what a lot of people have to do I suppose. I saw 12 mins of that Paris film, there was a strange beauty in the mix up of death & joy, of dogs, bicycles, many many women, barricades, fearlessness – but the suffering & corpses are only too real to me – the hand grenade thrown into the lorry of Germans that set them alight so that men crawled away burning like torches – that is the crucifixion – the extremity of suffering but made *unclean* by Science. Nature is brutal, very brutal, but cleanly so. Science has turned the Leonardo vision of flight into a hard, bright explosive passage through the air, bodies burn & crash burning through space, flesh is filled with bullets or torn up with bits of iron & then Science uses Penicillin or skin graft & sends them back for more. . . . It seems clear to me that unless we fight like the devil for every human & creative value our senses cannot survive the cold power of a machine age.'

Early in 1934 Barbara became pregnant.

'I don't know about this baby,' she said. 'It's so lively it feels as though it were playing a tennis match inside me'.

Her doctor thought that she might be having twins and suggested an X-ray, but an X-ray would have cost five pounds and

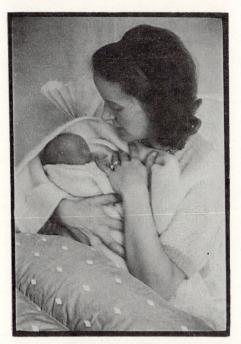

Barbara with Simon
October 1934

Barbara preferred to save the money in case she would need more baby things. Towards the end of her time she and I would often spend an afternoon at one of the local cinemas in the hope that gangsters and cowboys and the bangs and crashes and collapsing buildings of the San Francisco earthquake would hasten the birth. They didn't.

Barbara was to have the baby at home – or rather, in the little basement flat that she and Ben had taken just round the corner from the studio. It was there that we had supper and sat playing rummy on the evening of October the second. Soon after ten Barbara said that she was tired and would go to bed, and I left for home. It must have been at about four in the morning that my phone rang.

'Hullo,' I said, half asleep.

'I thought you'd like to know' – it was Ben's voice – 'there are three babies – a boy and a girl and I'm not quite sure yet what the third is.'

'Ben! It can't be true!'

'Oh yes it is,' he said. 'I bet you a bag of sweets it's true,' and he rang off.

When I awoke next morning I was sure that I must have dreamt it. All the same, I rang Ben.

'You didn't phone me in the middle of the night to say that there are three children, did you?'

'Yes I did. A boy and two girls.'

'Ben!'

'Why, do you think it's too many?' he asked jauntily.

The babies were tiny and only the boy, Simon, who was the largest, could be taken into the room where Barbara lay, exhausted. The two girls, Sarah and Rachel, had to remain in the even warmth of the other room.

'It's awful not being able to see them,' lamented Barbara, 'but Ben gives me such sweet descriptions of them – exactly what they look like; he notices everything – their fingers and toes and the way they scrumple up their faces.'

Barbara had to stay in bed for several weeks, as was then the

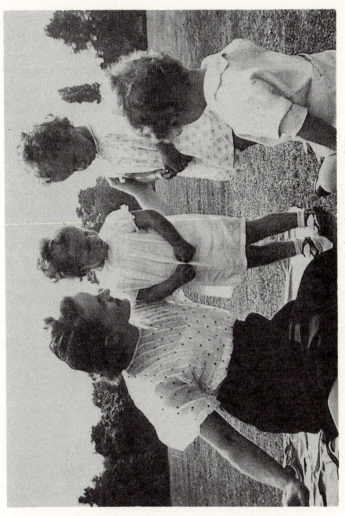

Barbara with Sarah, Rachel and Simon *c*. 1937

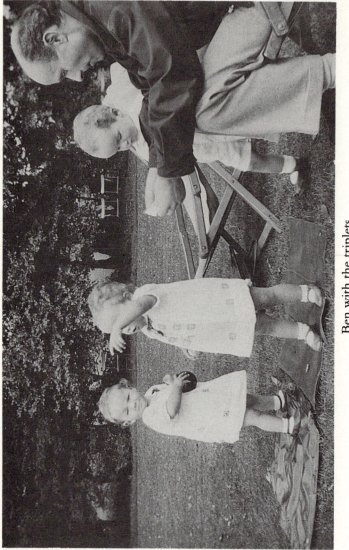

Ben with the triplets

custom, and she was at her wits' end. The triplets were lovely and she was delighted with them and yet how could she both work and look after three such tiny babies who needed very special care, day and night? She knew she had to work for financial reasons and also because of her own inner need. In her weakened state she felt quite desperate despite Ben's cheerfulness and support and, she told me, she cried for days on end. She couldn't stop.

The midwife had cancelled her other engagements and had stayed on for night duties while Barbara's sister, Elizabeth, took over for the rest of the time. But a more permanent arrangement had to be made and the nearby Wellgarth Nurses Training College seemed to offer the best solution. They agreed to take care of the babies for their first years at reduced rates. Barbara and Ben reluctantly accepted this offer; they knew that the children, who needed skilled nursing, would be given it there, and since the Wellgarth was so close, they would be able to visit them very frequently. It was a hard decision to make and Barbara often regretted it in later years – but at the time it seemed the best course, and they had little choice.

When the triplets were three years old, Barbara and Ben took them away from the Wellgarth and installed them with a nanny in one of the Mall studios, a few doors away.

'I really ought to have three hands,' said Barbara. 'Can you imagine trying to cross a road with three lively children all wanting to run off in different directions? And what is one to do when faced with three children sitting in a solid row on the stairs and saying in unison "*We won't move*"?' She laughed. 'They're impregnable. I just give in.'

Naum Gabo, whom Barbara and Ben had already met in France and whose work they greatly admired, came to live in England and took a room nearby in Hampstead. Small and compact, with a look of slightly puzzled expectancy and a slow smile, he enchanted us all. He had left Russia when, after the first heady excitement and sense of liberation of the early days of the revolution, official art was decreed and experimental art no longer tolerated. Gabo refused to

compromise and since at that time those who would not conform were still free to leave the country, Gabo left.

He had a passionate belief in what he called the constructive idea, the totally new direction of art that stemmed, in his view, from a reaction against the destructive explosion of cubism just as – and at almost the same time as – physics had taken a new direction as a result of the theory of relativity. Art and science, he maintained, have always developed and changed course more or less simultaneously; they are two different streams which arise from 'the same creative source and flow into the same ocean of the common culture, but the currents of these two streams flow in different beds'. And he was convinced that 'in the light of the constructive idea, the creative mind of Man has the last and decisive word in the construction of the whole of our culture'.

This didn't mean that Gabo considered his own work 'last and decisive' – on the contrary, he stated that 'there is no place in a Constructive philosophy for eternal and absolute truths. . . . "Perfection", in the Constructive sense, is not a state but a process; not an ultimate goal but a direction. We cannot achieve perfection by stabilising it – we can achieve it only by being in its stream; just as we cannot catch a train by riding in it, but once in it, we can increase its speed or stop it altogether; and to be in the train is what the Constructive Idea is striving for.'★

The conviction that what he and his fellow artists working in the same direction were creating was something altogether new and unprecedented and which had the power to transform society, was fundamental to Gabo's apocalyptic vision. His own beautiful and lucid sculptures – constructions in space, he called them – in which 'space is an absolute sculptural element, released from any closed volume' were of great importance in this new conception of art. Space as an element in sculpture was not, of course, a new discovery – but Gabo's use of it and his use of a new material – perspex –

★ The quotations from Gabo come from his essay 'The Constructive Idea in Art' in *Circle* (Faber & Faber, 1937).

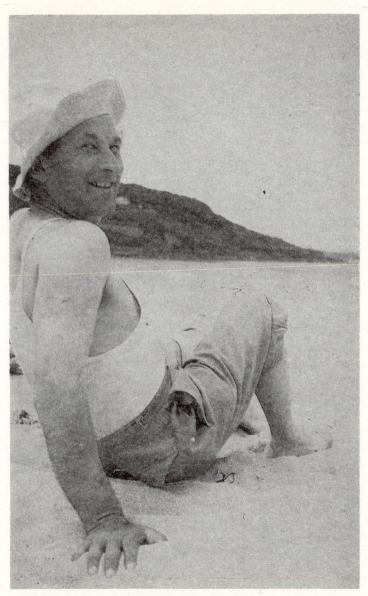

Gabo in Cornwall

was an exciting development. So sure was Gabo of the immediate comprehensibility of his idea that when one of his works had been left in a taxi – alas, never to be recovered – and he reported the matter to the police, his answer to the question 'What is it exactly that you have lost?' was, to their bewilderment, 'A construction in space'!

Gabo spoke English with fluency and conviction but didn't always get it right.

'Why are you staring at me like that?' I asked him once.

'Oh Margaret, it's that continence of yours!' was his rather surprising reply.

Another time I remember, in the little Italian restaurant in Hampstead where we sometimes all of us ate and Ben was affection- ately known as 'Mr Double Ice Cream', Gabo asked me, 'Darlink, what is this on the menu?'

'Hash,' I said, 'Hashed meat.'

He looked shocked. 'Hushed meat! Oh no, I don't eat hushed meat.'

Ben had always had a passion for ice cream. He wrote to me once from the Ticino, 'The seaweed green of summer has all gone off the mountains & a marvellous autumn brown in place of it & the first snow on the highest mountain tops – most lovely – like cold choc sauce on hot i scream. . . .'

I wish that I could now remember – or had then written down – all that Gabo told Desmond and me one evening about his time in Moscow at the beginning of the revolution. He had been given a studio above the Admiralty and from the window he was often able to watch the leaders of the Government going in and out. What I do remember was his shining enthusiasm when he described Lenin addressing a meeting – Lenin, a small man with an aristocratic lisp and one shoulder higher than the other, whose personality and eloquence held the crowd spellbound. As he told it to us, Gabo was vividly there again, seeing it all, elated, oblivious of the present. Nevertheless Gabo hated the violence and destruction of war and revolution. 'Think what it takes to make a man,' he said, 'the

years of love and care that can so easily be destroyed in a single moment.'

Gabo had an absolute belief in his own ability to read handwritings – not scientifically, but intuitively. I once gave him a letter from a friend and asked him to tell me whatever he could about it. He glanced at it, sat holding it in his hand for some minutes with his eyes closed and then, opening them, looked at it carefully. I had expected a character analysis but it was a warning of the future that he gave me. He told me that in spite of what I imagined, things would not go well between the writer and myself and that I would very soon be getting disturbing news. He was right: the bad news came in a letter next day.

Towards the end of his years in England and as the war ground on, Gabo became more and more despondent. He found it increasingly difficult to work and his vision of a world redeemed by constructive art seemed further off than ever. Finally in 1946 he left the country to settle in the United States. Barbara wrote to me, '. . . A very charming and illuminating letter from Pevsner [Gabo's brother]. I have just written to Gabo in the hopes that good food & 3000 miles will have brought back his smile. He may be too deeply wounded about me not wanting to be called "constructivist". I wonder if he'll ever understand – it is such a religion with him. It is with me, also, but in a different sense. I hope my work will always be constructive but I don't want to be called "ivist" any more than "Nicholson"! Pevsner says that I make "Austrian politics" – (I liked that very much & laughed at myself). He may be right; but though Pevsner says my work is constructive (to be exact "realisme constructeur" a new word!) I doubt whether Gabo would like what I do now & in any case it is not important to me what one is called! To Gabo it seems to be important & he does not understand when Ben and I like Picasso Miro Klee cubism etc, etc. He hates all that, it is anathema to him – but for me it is pure enjoyment & I'll never belong willingly to group or party that represses the natural flow of enjoyment & love for all facets.

'Dear Gabo – I hope one day he'll smile at me again. That smile

& his handshake are the very essence of the enjoyment that matters so much.'

Many years earlier Barbara had written to me, 'The contacts I love are those which lead to a concrete development of ideas – *Circle* was born like that & other books & exhibitions'.

Circle was, in fact, born in an ABC tea shop where Barbara, Ben and Gabo had gone to restore themselves one day in 1936 after viewing the Surrealist Exhibition and where they decided that they absolutely had to do something to clear the air. Out of that tea-time talk and many later discussions with friends came the decision to produce a book of contributions from artists whose common basis was the constructive trend in contemporary art, a book with the dual purpose of bringing the work before the public and of giving the artists a means of expressing their views and of maintaining contact with each other. Gabo, Ben and their architect friend, Leslie Martin (J. L. Martin) undertook the editing and in 1937 this significant and influential book was published.

It was a dazzling achievement. Not only painters, sculptors and architects from ten different countries contributed, but also experts in other fields, among them Herbert Read, Desmond Bernal and Lewis Mumford. Yet another contributor – writing about choreography – was Leonide Massine, whom Ben particularly admired. Ben told me that he'd once seen Massine driving a car round Piccadilly Circus, in and out of the traffic, with all the verve and stylishness of his ballet dancing. To be a dashing driver was always to receive high praise from Ben, himself a dashing driver who loved fast and well-designed cars.

Mondrian, another contributor to *Circle*, was in England from 1938 to 1940, and had a studio just round the corner from Mall Studios. Although he certainly saw a great deal of Barbara and Ben, I only remember meeting him once, and I don't think that I had, at that time, seen any of his paintings. Somehow he seemed to me incongruous in Barbara's studio. I was used to seeing Ben there,

casually elegant with a bright scarf round his neck – and Gabo was often there too, in very pale tweeds that matched his pale complexion and made him look like a piece of old ivory. But Mondrian was quite different; he was dressed in dark, conventional clothes and seemed to have none of the panache and vivacity of those other two. He stood very stiffly, with straight arms pressed close to his sides as though defending himself against some dangerous intrusion. And when Barbara introduced me to him he was courteous but didn't smile. A puritan, I thought, a Dutch puritan, akin to the stern Arnolfini – and certainly in his essay in *Circle* purity is a central theme; the words themselves – pure, purity and purification - recur over and over again.

Mondrian's painting meant a great deal to Barbara. And Ben has told me about the effect on him of the *feeling* of Mondrian's studio in Paris when, for the first time – and before he understood the paintings – he visited it. He left in a daze of delight and sat for a long time in a chair outside a nearby café, one foot on the pavement and the other planted in the street – unaware of danger from traffic going towards the Gare Montparnasse – completely absorbed by the memory of what he had seen.

Later Ben wrote to me, 'I feel that one could take Cézanne & Picasso & Mondrian & know all about contemporary ptg without having seen anything else. The Mondrian vision is an altogether smaller thing but it is vital because it supplies an element missing from the others.'

It was, in fact, a cubist painting by Picasso that Ben had seen in a corner of Paul Rosenberg's gallery in Paris – a painting with a vivid green somewhere in the middle – that had made the first great impact of abstract art upon him and had proved the turning point in his own work.

I met Sandy Calder (Alexander Calder) with Barbara and Ben when he was in London in 1938 – a great, burly, rather rough-shod man who contrasted oddly with the delicacy of his early mobiles. He was

also at that time making jewellery and I watched him once as he hammered brass wire into flat spirals to make a splendid necklace for me. He made me a pair of earrings to match – but I kept on losing one or other of them and asking him to replace it until I hadn't the nerve to ask him yet once again and so I banged a pair out for myself on the kitchen floor.

One evening Sandy showed a small crowd of us his Circus in the studio of Cecil Stephenson, the painter who lived next door to Barbara and Ben. The 'ring', strewn with sawdust, looked most authentic; there was a barrel of beer and we all sat, mugs in hand, on the floor, while Sandy manipulated his marvellous little creatures made of wire, wood and rag. They seemed incredibly alive as they pranced, pirouetted and clowned, more real than the real tinsel thing. It was enchanting.

I think that Barbara with her Yorkshire background and early memories of miners and mill hands, was always concerned with politics and social problems. But I and many of my friends were only vaguely interested until we were moved to a greater awareness by the hunger marches and the heartbreaking little groups of un-employed Welsh miners singing in the streets of London. With the coming to power of Hitler, the ever growing menace of war and the sprouting of the British fascists, we became fiercely partisan, and the outbreak of the Spanish Civil War concentrated our feelings and sharpened the sense of urgency and imminent disaster. At that time it seemed a clear black and white situation, a clear choice between evil and good. And that, I think, really was the choice – though perhaps more complicated and not quite so clear-cut as it then seemed.

Early in 1936, in response to a plea from the French Societé des Intellectuels Antifascistes, an organisation called For Intellectual Liberty – generally known as F.I.L. – was formed and I became the secretary. Its object was to be a rallying point for those intellectual workers who felt that the condition of the world called for the active

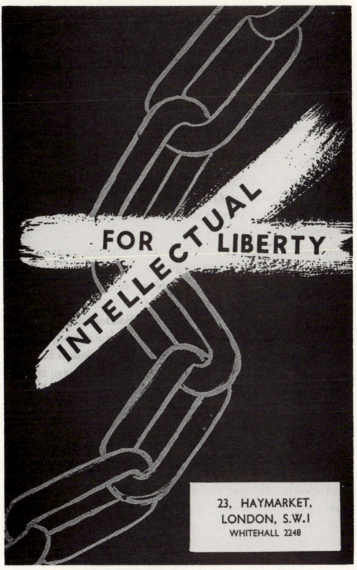

FIL pamphlet designed by Moholy-Nagy 1936
(*Original: prussian blue on white*)

defence of peace, liberty and culture and its means were letters and personal representations to M.P.s, Ministers and other authorities; deputations to foreign embassies and the publication or other dissemination of information not easily come by elsewhere.

I was anxious to have a really well designed cover for our brochures and Barbara suggested that I should ask Moholy-Nagy – a contributor to *Circle* – to make one for us. So I went to see him at Simpson's shop in Piccadilly, which he was then re-designing. Round and genial and a little puzzled – for we had never met before – he smiled charmingly when I told him what it was that I wanted.

'For the liberty – yes,' he said.

And sure enough he designed us a cover which we used until F.I.L. was dissolved at the beginning of the war when the organisation was no longer needed since the whole country had become anti-fascist.

Ben had written to me, 'There is at least this that all the badness in humanity is *coming to the surface* & can be tackled openly – I had no idea such things *existed* – I suppose one just shut one's eyes to it.

'I went to see Harry [Henry Moore] on Sunday & he came back & Barbara & he had a long political talk – he's a *very good* chap, gets better the more one knows him. He apparently joined the Communist party about 6 months ago.'

Certainly Harry was on the committee of F.I.L. and always attended meetings although he rarely spoke. If Ben's surmise was correct and Harry had indeed joined the Communist party, this was not so surprising as today it might appear. The doctrine of communism is, after all, an idealistic one and at that time our knowledge of what was happening in the Soviet Union under Stalin was very imperfect. Fascism was the enemy and yet in Britain there was a widespread indifference to it and even, in some influential circles, support for it. Many people joined the C.P. because Russia and communism seemed to be the best – perhaps indeed the only – hope of checking fascism and saving Europe.

Ben had concluded his letter, 'I expect you saw Picasso's reasons for joining – in case you didn't I'll copy them out'. And he

transcribed Picasso's long statement, which contained the sentence: 'I have become a Communist because our party strives more than any other to know and to build the world, to make men clearer thinkers, more free and more happy'.

Some years later Barbara wrote to me, 'Re Picasso – I haven't any definite information but knowing him & the work I should say he'll paint just what he feels & do as he likes. Later on – he'll be expelled! Unless he grows old too quickly but I can't believe that.'

Barbara herself thought very seriously and over a long period about joining the Party. Early in the war she wrote to me, 'I think the only way in which people of our generation will go on making a useful contribution is to accept now the fact that certain privileges such as leisure, continuity, exclusive privacy, quietness & a host of other things are gone forever. Even if we could attain them for ourselves they would be barren & we should be uneasy. I don't mean that I've changed in any way my work ideas – they become more fiercely convinced in their personal & essential quality. But the method of living must be different & will be different . . . we are much preoccupied (all of us [Barbara, Ben and Gabo]) in thoroughly working out the living status of artist to society & that will never be solved by a commission of Fine Arts but only by the artist being allowed to take his place along with other workers.'

Some time later she wrote, '*Yes* I would like to join the Party but for 3 things 1)I have a primary allegiance to aesthetics & it would always come first 2) I don't know how it would affect my relationship with Ben 3)I can't make up my mind whether I'm emotionally stable – that is, should I want to be free the moment I gave my word to a set thing which I could not control? . . .I hate unfeeling things.'

'When Russia had come into the war, was an ally and was turning the tide of defeat, Barbara became very impatient with the political attitudes of some of her friends – even though she herself still couldn't decide whether to join the C.P.

'The difficulty is how and where to act – where is the power & virility?' she wrote. 'I know so many people who talk & believe

socialism, who recognise Russia in the full sense, who sense hypocrisy & hate it, & yet who will, indubitably, as in hypnosis, vote Tory next time.'

And again, 'I think A. [Adrian Stokes] reads too much reactionary literature. He says there'll be communism after the war & that then we shall be all right but that he will starve! I wrote & suggested to my Mother that she should start right now & nip any Bolshevik Bogey from neighbours & friends right in the bud. She got the point and wrote back a witty letter saying "Oh yes, the Russians will be in Leeds at any moment now. . . ." When eastern Europe solves its problems in the obvious & only way we shall need to combat colossal reaction here & right now I think we might as well start.'

It was only when the war was over and after many political discussions – above all with Desmond Bernal – that Barbara finally made up her mind. She wrote to me, 'I was shocked to the bone by Des's remark re political illiteracy – it sounds so incredibly snobbish; & anyway, if policy is all in all, who then is capable of giving most to society! It conjures up such an awful vision for me – I cannot bear it. What about musical & philosophical literacy – also literacy in the arts, painting, sculpture, design – & social literacy in architecture, planning & all social comprehension.

'I cannot understand how a rare mind like Desmond's can tighten up – or be snobbish. The whole point of his individual contribution so far has been in his creative ability to see round corners.

'Who told him it was bad to explore? It is, alas, just one more proof of the disastrous result of toeing any party line. . . . I must try to have a discussion with Des but hope he won't be impatient with my illiteracy!'

After Barbara had achieved that discussion with Desmond, she characteristically made a very thorough examination of her own attitudes. She wrote to me, 'Before I can answer your letter I must put down what I feel about Des for the simple reason that contact with him has shaken up every part of me, explored every corner & resurrected a multitude of vivid impressions & memories. All of which have now settled down again into a more powerful cohesion

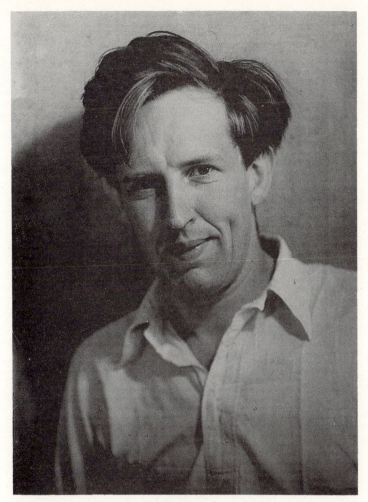

J. D. Bernal

& much tougher kind of structure. When I said "goodbye" to Des the other day I felt I was saying *goodbye* to a very dear friend & simultaneously I had a vivid picture of him as my executioner. . . . There is the question tho' of my book – I could not ask him to write about my work when he feels the work is useless & I am re-actionary. This is of no importance at all as far as he or I are concerned personally, but it is of paramount importance in relation to society at the moment. You see, Des has provoked the most violent & bitter antagonism from many quarters during the last few months. I doubt if he knows how considerable it has been from people of all ages & professions. Up till now I have sided with Des on the conviction that he was the man I knew before, a person I felt to be a leader & creator. Now there are 2 men! & the more recent man prefers to "drive" & "produce" & with a toss of the hand relegates everybody from Russell to Read to Freud, Mumford (Geddes if you like) into the waste paper basket out of rage. The artists are merely the remaining dust to be swept up. It is this *religious* fanaticism of his – this blind doctrinism – which shocks me so because of the respect I have had for him in the past. It is a nice point to decide which of the 2 men is of more use to humanity ultimately.

'He seems to me to have become very negative because the shutter is down between the inner man & the Party member. I have studied the word reactionary – "recoiling from progress" "retrograde" "moving backwards to an inferior state" etc.

'Here it seems necessary to define progress! "Forward movement, advance, improvement, development, increase, advance in morality & civilisation." This seems to be the key.

'Progress to me is: 1) Acceptance & understanding of the machine & power age. 2) Research into its benefit & detriment to man, both biologically & psychologically. 3) Finding a true way of *controlling* the power gained in our age by constant reference to history & culture so that proper understanding of *all* the "needs of man" co-ordinates the needs & the power.

'I'm the *last* person to refute the machine – or wish to go back. Most ardently I wish to resolve the whole thing; but I should

consider myself imbecile to accept each new discovery as good itself because it's new or scientific. Hundreds have written creatively on this subject & my limited words don't contribute anything, but in my sculpture I link up with all the discoveries in architecture & engineering; & in art – or the realm of aesthetics – each person is vital & the sum total is a gigantic influence on the unconscious. Thank goodness for it!

'I don't know where Des got the "avowedly reactionary" from; in our conversation the only thing that might have given him such an idea was our discussion of new ideas for carving. He was delighted with some new materials – I put up a strong plea for "live" materials for carving as in my opinion the fault of the new materials is in their deadness of colour, weight, texture & temperature. But – I still hope that a block of live "new" material will come my way. Meanwhile I consider that the average design in plastic is an anti-sculptural, hypocritical & smug abortion. That is part of the fight we are engaged on! The diagnosing of these things & developing an intuition & assessing the effect of everyday things. . . .

'Anyway – it's all useless & really so primitive – this sort of argument. The only discussion I'm interested in is the one where one accepts certain premises & then discusses all the many possibilities of change & co-ordination, using all our knowledge and not half of it. And using all men as being vital living tissue (with biological needs), with individual subconscious images (as well as archetypal) & with anarchic individual life (as well as collective).

'Des's idea of our isolation as an excuse made me smile. It supposes that the ideas of agricultural workers, fishermen, small town officials, local C.P. members, Labour members & officials etc, are of total unimportance. I find particular importance in the keenness of feeling in small town units, in decentralisation & the microcosm. It is more coherent & dynamic & goodness knows I have plenty of contact with intellectuals & all creative products. Only one thing I lack & *I know it*, that's contact with factory workers – but my knowledge of the mills in Yorkshire & 18 years intimacy with all that goes with collieries & mills is so alive in me that imagination

helps me over the difficulty up to a point. Also by living among a less mutilated set of people (than is found in London) I have discovered how rich in response each man really is. . . . It is all too easy to regard men in the mass as stupid. But it all depends on one's job – how much contact one needs. However, according to Des's view, nobody in a small town is capable of holding a legitimate political idea! This seems contradictory to ideas of progress – Radio, newspapers & instantaneous knowledge generally. . . .'

Barbara added a postscript, 'Also Des was so charming – kind, generous & *illuminating* – I wish one could forge a stronger link. . . . I suppose I had to get over my secret hope that the C.P. would expand & grow richer. . . .'

A little later Barbara wrote, 'I'm feeling less depressed & quite over my wishful thinking, such as it was, about the C.P. Each day I feel more energetically opposed to ideas which underestimate the innate beauty and goodness in people. I do hope Des has the same effect on other people he talks to – because if not he could give considerable cause for "alarm & despondency" (his own accusation against heretics!)

'I must try not to resent intellectual snobbery. I expect one only resents it because of fear. Fear of a "new aristocracy" is the prevailing fear & perhaps that is what one should try to grapple with in all its forms – whether it is an aristocracy of C.P. members, artists, business men, atom bomb holders or writers.'

And later still, Barbara wrote, 'If I could see the faintest glimmer of hope that the C.P. could offer creative integrity to the artist I should endeavour to work my passage to be a C.P. member. I don't see it & so I can work more clearly, free and through my own sculpture & sculptural integrity. . . .'

'The tragedy is that 5 years of war could not resolve the inevitable fermentations of world change. Had the war been averted we could not have avoided the sequence of this political & social upheaval – but we could have saved needless killing & maybe 3 years in the course of revolutionary change. On the credit side we have to put our greater understanding of Russia & political issues. The debit

side is gloomy because we have exhausted our strength & vitality on so much abortive force. There will be fearful trouble – it cannot be avoided – the nostalgia you speak of is only the symptom of an unconscious recognition of this fact. There will be bitter fights, civil war in many countries, deep social hatreds & awful suffering & we shall not see much else in *our lifetime*. Therefore it is doubly important to keep a clear head with great faith & sound reality. Even *one* person can hold a multitude by these qualities so let's all keep in touch with each other because loneliness is the hardest.'

I don't know how Barbara ever found the time to read – but she did. She read widely, not only books and newspapers but also the weekly papers, the literary and art magazines and poetry.

' . . . I was terribly depressed after reading Oct. *Horizon* reports on the Soviet magazines "Svezda" & "Leningrad". Have you read it? I simply didn't know that words & context could be so *horrible* as these party ultimatums. I felt quite sick.

'On the other hand there was this fine talk by Jung printed in this last week's *Listener.* . . . I found it quite remarkable & intensely reassuring. I have scored it all over in readiness for seeing Des in December!'

Barbara's letters to me were sprinkled with comments on what she was reading. 'I expect you have read William Plomer's "Double Lives". I like it very much *indeed*. Just plodding on arduously through R. L.'s [Rosamond Lehmann] new book. I find it difficult to express my feelings about such work – I don't like it at all – it is a misuse or an invasion of all I care for. I shall have to read something robust to clear my mind. I suppose my dislike is because all the trappings are so efficient. That book & Moore's "Virgin & Child" are 2 things which have disturbed me profoundly – & their effect on people.'

During the war I wrote a number of short stories and always sent them to Barbara for her criticisms. She read them very carefully and constantly urged me to keep on writing.

'To create one lasting thing in a lifetime,' she wrote, 'is an affirmation of what we are fighting for – of course there are other things to do – political, social & family – but they must be welded into a coherent wholeness & into our experiences. . . .

'I feel that contemporary writing is that which gives the full flavour of the present day values which contain germinating capacity for life tomorrow. That excludes all reactionary present day thought, all spurious left wing & all mysticism practically - except the strong faith in the resilience of human nature.'

It was, she wrote to me, with a sense of outrage that Barbara had read a newly published book 'in which I & Jack & our marriage & work figure rather largely. . . . He [the author] never got in touch with us or attempted to verify facts which are terribly muddled & quite wrong in many instances. . . . He does it nicely & kindly according to his lights I suppose, but the element of the sensational gets me down. Fortunately this book stops at 1928 – but what protection is there against a similar kind of thing coming out in later years giving such a one-sided and faulty interpretation which appeals so largely to sensation? I wish some creative person could write down the facts & feelings – seen through the eyes of a real writer the lives of J & I, & B & W, & B & B etc, etc would, though full of our faults & weaknesses, at any rate have truth, order, aliveness & sequence which would make sense for our grandchildren & be without the horrific sensationalism. A job for you Margaret?'

I suppose that after many years facts – particularly facts about feelings – if such *facts* exist – can't always be verified and are often muddled and wrong. Memory both veils and fails, selects and interprets, glosses, distorts. I am not able to do what Barbara asked – too much has intervened, the laurels all are cut – but I hope that she would have found that what I have written is as near to her own truth as it has been possible for me to come.

After the shameful respite of the Munich Agreement it became clear that war was inevitable, that it was just a matter of time.

Herbert Read, M. G. and Ben Nicholson. Carbis Bay, *c.* 1942

Am I crazy? — It seems to me that living is. like making a painting & that somehow each move must be "felt" i so that finally everything falls into place intuitively. At least I hope its like that !

I must sleep. All my love & all my thanks Margaret dear — ivr — Barbara

Barbara's handwriting

Plans for the evacuation of children were being urgently considered; it was generally believed that within a few minutes of a declaration of war London would be bombed to near destruction. Adrian and his painter wife, Margaret Mellis, had bought a house in Carbis Bay, just outside St Ives in Cornwall. Barbara didn't know St Ives, but Ben had seen it and had loved it; he had spent a day there some years earlier with Christopher Wood and together, glancing through an open cottage door they had discovered the grumpy old fisherman, Alfred Wallis, at work on one of his marvellous paintings.

Barbara was deeply worried about what to do for the best for the children if war broke out. But Adrian, who had invited the whole family for a holiday in Carbis Bay, had reassured her, telling her that if war came they could stay with him until they were able to find a place of their own. So, one afternoon in late August, 1939, they all piled into the ancient car and drove to Cornwall, arriving at midnight in pouring rain. And the war came down on them there.

Finkelstein

Index

St. Louis Community College
at Meramec
Library